ART IN THE

NINETEENTH CENTURY

ART IN THE
NINETEENTH CENTURY

by

CHARLES WALDSTEIN,

Litt. D., Ph. D., L.H.D., Fellow of King's College, Cambridge,
and University Reader in Classical Archæology; Sometime
Slade Professor of Fine Art and Director of the
Fitzwilliam Museum

Cambridge

at the University Press

1903

CAMBRIDGE UNIVERSITY PRESS
Cambridge, New York, Melbourne, Madrid, Cape Town,
Singapore, São Paulo, Delhi, Mexico City

Cambridge University Press
The Edinburgh Building, Cambridge CB2 8RU, UK

Published in the United States of America by Cambridge University Press, New York

www.cambridge.org
Information on this title: www.cambridge.org/9781107619340

First published 1903
First paperback edition 2013

A catalogue record for this publication is available from the British Library

ISBN 978-1-107-61934-0 Paperback

PREFACE.

A FTER the delivery of the lecture here published by
the Syndics of the University Press, Dr Roberts,
Secretary of the Cambridge University Extension Syndi-
cate, wrote to me that "a number of students are very
anxious to have the lecture, The Achievement of Art in
the XIXth Century, in print. Nearly 150 of them have
already signed a petition to that effect. Can I now
announce that the lecture will be published?"

The lecture served as an introduction to the section
dealing with Art, Literature and Music, and was delivered
at the Theatre Royal, Cambridge, on Aug. 2, 1902, under
the title: "The Achievement of Art in the XIXth Cen-
tury." The course which it served to introduce formed
part of a series of lectures, all dealing with the XIXth
Century, organised by the Extension Lectures Syndicate
of the University of Cambridge for the summer meeting
of extension students at this University.

The lectures and courses of this section were:

W. A. S. BENSON, M.A., On House Decoration in
the XIXth Century.

OSCAR BROWNING, M.A., The Evolution of Goethe's
Art.

The Rev. E. CAPEL CURE, M.A., Wagner and the
Operatic Drama.

J. CHURTON COLLINS, M.A., Walter Savage Landor.

ALFRED EAST, A.R.A., The Outlook of Landscape Painting.

ALFRED GILBERT, R.A., Sculpture.

I. GOLLANCZ, M.A., Cambridge and the Elizabethan Drama.

J. W. HEADLAM, M.A., Romance and Politics in German Historical Literature.

A. A. JACK, M.A., Relation of Poetical Literature to the English Stage in the XIXth Century.

T. G. JACKSON, R.A., English Architecture during the Past Century.

S. C. KAINES SMITH, M.A., Heraldry in the XIXth Century.

Professor W. KNIGHT, Litt.D., Reminiscences and Retrospects:

(1) Carlyle, Maurice, Newman, Martineau.

(2) Tennyson, Browning, Ruskin, Lowell.

SIDNEY LEE, Litt.D., National Biography.

B. MINSSEN, M.A., Victor Hugo.

Professor R. G. MOULTON, M.A., Nineteenth Century Developments of Shakespeare's Materials:

(1) Scott's White Lady and Shakespeare's Ariel.

(2) Browning's Caliban upon Setebos and Shakespeare's Caliban.

E. W. NAYLOR, Mus.D., The Sonatas of a Century, illustrated by Violin Sonatas of Mozart, Beethoven, Schumann and Brahms.

J. C. Powis, M.A., Some Modern Poets:

 (1) George Meredith and Thomas Hardy.

 (2) Rudyard Kipling and Stephen Phillips.

The Very Rev. C. W. Stubbs, D.D.:

 (1) Ely Cathedral.

 (2) The Uses of Poetry in Education.

A. Hamilton Thompson, M.A., Two Novelists:

 (1) Thomas Love Peacock.

 (2) Benjamin Disraeli.

I have written out the lecture (delivered from notes), as nearly as I could remember it, in the form in which it was originally given. In a few instances only, where the limitations of time imposed by one lecture forced me to give but a hurried allusion or suggestion, I have allowed myself to amplify and to develop passages to a slight degree in this written form. In a *vivâ voce* exposition a mere suggestion, enforced by the living voice and gesture, becomes intelligible and significant which would be pointless when rendered literally in writing. Still I have endeavoured to preserve its character as a lecture while preparing it for print, and I hope it will be judged as such.

My best thanks are due to my friends Dr M. R. James and Mr G. L. Dickinson, both Fellows of this College, for suggestions and corrections both in manuscript and proof. Though I feel sure they have freed my style from some of its eccentricity, I doubt whether they have been able to dispel all its obscurities.

<div style="text-align:center">CHARLES WALDSTEIN.</div>

King's College, Cambridge.
January, 1903.

ART IN THE NINETEENTH CENTURY.

I. INTRODUCTION.

Sedulo curavi humanas actiones non ridere, non lugere, neque detestari, sed intelligere.........Et mens...vera contemplatione aeque gaudet, ac earum rerum cognitione, quae sensibus gratae sunt.

SPINOZA, *Tract. Pol.* I. 4.

I have studiously endeavoured not to laugh at, not to deplore, nor to despise human actions; but to understand......And the mind... derives the same kind of pleasure from true contemplation as from the perception of those things which please the senses.

IN his opening address yesterday the Vice-Chancellor gave us timely warning that we stand as yet too near to the nineteenth century to talk of it as a whole. He also maintained that the grouping of events did not necessarily coincide with the divisions of time by calendar and clock. Nature and history have not been so obliging to the desires and needs of the human mind, and neither assume, as we are too apt to do, that man and human thought are the centre and pivot of all events and phenomena. The apprehending mind is of course easily led, nay driven, to assume that its own laws which regulate thought immediately control the course of natural

w. I

and historical phenomena; and though the *apprehension* of those phenomena is certainly dependent upon these "laws of thought," most errors in apprehension have resulted from the premature projection and intrusion of such laws into the world of phenomena itself. Still more misleading and distorting in this respect is the artistic instinct of man, which craves for harmony and "composition" in all things; of this I shall have more to say presently. This instinct tyrannises over the mind, and constantly urges it to clip away corners, add a little curve here and there, force facts into "proper" sequence and coincidences— so that they should all become clear, pleasing, or wonderful—until in fact, amorphous, disjointed, or incomplete phenomena present themselves as an orderly and compact whole about which it is easy and safe to predicate and generalise. And thus we insist on having a compact nineteenth century with its birth, rise, climax and gradual decline, decay and death, on the symmetrical analogy of all other regular and "normal" life. This lends itself to artistic composition.

Have you not of recent years felt with me an irritation, an exasperation, almost a "holy" scientific indignation, when you have heard young and old, wise and foolish, thoughtful and brainless people, subtly suggest or blatantly mouth the phrase "decadent" or "*fin de siècle*," with a smile of pregnant, familiar and intimate understanding, at the bottom of which there was a suggestion of a world of unexpressed meaning, perhaps verging on the improper

and indecent? Well, there was no decadent *fin de siècle.* Far from feeling ourselves to be decadents we ought to feel like children growing up. I have felt myself in these last years, and I feel myself now, an *incipient nascent* in the very midst of a vigorous life surrounded by the germs and the growth of great things in all matters human—so great, important, and epoch-making, that I doubt whether in the whole history of the race a like outburst of energy can be found.

This is enough to suggest to you the difficulty of generalising about the nineteenth century.

My own difficulty, in the special subject with which I wish to deal, has been caused by the wide and peculiar sense which I wish to give to the term Art, a meaning which is not always attached to it here in England. For I give to that term a significance so wide and comprehensive that it runs counter to the ordinary use of the term in the English language— or, rather, in the language of England. For in the United States it is used more correctly.

In England the term Art is generally limited in its application to painting and sculpture, perhaps including architecture; as the term Science is (with the same fatal consequences to correct understanding and to the intellectual and practical life of the nation) narrowed down to designate the natural and exact sciences. This narrow or incorrect use of the term Art has in this country stood in the way of the proper understanding of things artistic, and vitiates our esti-

mate of the artistic achievement of any country or age. I am therefore grateful to my friend Dr Roberts and to those who helped him in organising this meeting, for enabling me, in the organisation of the course to which this lecture is to serve as an inaugural address, to define the true nature and position of Art and to counteract the misleading definition of its province.

The Germans and the French employ the terms Science and Art more consistently and logically than we do. With them Science means all forms of conscious and systematic apprehension, Art includes all forms of aesthetic enjoyment. The one deals with the life of knowledge, the other with that of the contemplative emotions. Both are *theoretical*, and in so far they are distinguished from the practical, from action as such.

Art arises out of man's natural desire for harmony and proportion, which, I could show to you had I time, is the mainspring of all conscious endeavour of the human mind. In one aspect—a quasi-physiological aspect—it might be called the instinct of mental economy, which makes for the easiest and most rapid (and therefore the most pleasant) form of perception. All conscious endeavour to select[1] or to

[1] I should like to emphasise the word *selection*. For it is not always realised that the artistic function and activity of the mind need not necessarily lead to the elaboration or modification of the "raw material" out of which a work of art is fashioned; but that the selection of such objects as have elements of harmony and evoke artistic moods in man is

create objects of contemplation which correspond to an outer harmony, and evoke in man an inner harmony of mood, belong to the domain of art.

The works of art which man thus creates may be conveniently subdivided into the arts of space and the arts of time; or, from the point of view of the perceiving mind, those that appeal to the eye (including touch[1]) and those that appeal to the ear. The arts of space are thus concerned with the contiguity and relation in space of objects having themselves intrinsic qualities of density, form, and colour. The material of the arts of time are sounds, the order and quality of their succession and relation, as well as their intrinsic quality of pitch and form. The one has led to painting, sculpture, architecture, and all kinds of decorative art. The other has produced music, poetry, and prose literature.

also essentially an aesthetic act. The selection of beautifully rounded pebbles, symmetrical crystals and shells, is an act of decorative art just as much as the carving of rude stones into symmetrical and decorative shapes. The admiration of a landscape, of cloud-forms, nay, of the animal and human form—the freer it is from feelings of interested use or possession—constitutes an artistic act on the part of the observer: it originates from and appeals to those same artistic instincts which lead to the production of pictures and statues.

[1] I cannot here enter into the question of the relation of the "lower" senses, smell, taste, and touch, to art. In one respect they certainly partake of an aesthetic character. But on the whole they are so intimately and directly mixed up with the physiological subsistence of man as to exclude the disinterested and undesiring attitude of mind which leads to the pure contemplation of art and the production of the aesthetic mood.

For all practical purposes these distinctions are clear in your minds. The only real difficulty is to be found in the definition of literature as an art, namely, the distinction between the forms of prose literature which belong to art and those which belong to science. For, whereas the designed production of colours, lines and forms by the hand of man, and even of musical tones (not words), hardly ever takes place unless for artistic or quasi-artistic purposes, words are so essentially the means of thought and its communication, that their use for aesthetic purposes must be emphasised by more elaborate insistence upon form in order to bring them within the domain of art. But it will be enough to say here, that all prose literature in which the literary form is not merely the vehicle for imparting the results of scientific enquiry (and thus appeals to the sense of truth), but constitutes the essential feature of the work (and thus appeals to the sense of form and to imagination), belongs to the domain of art.

These being my views (which are here presented in a much condensed, and consequently inadequate form), it will be readily understood how I consider the definition of art which includes only or chiefly painting and sculpture, and does not include music, poetry and fiction, as fundamentally misleading. In making any estimate of the achievement of art in the nineteenth century, we should fail entirely in our endeavour were we, for instance, to exclude music and fiction. They are as direct and adequate expressions

of the artistic temper and spirit of our age, as architecture or sculpture and painting were for previous ages, arising, as they do, out of the same fundamental function, and satisfying the same needs of the human mind.

It is in this sense, therefore, that I use the term art when dealing with its manifestations in the century which we have just left behind us.

But before we enter into the detailed examination of the artistic achievement itself, there is one other fallacy, widely current in connexion with my subject, which I wish to expose. And I hesitate the less to do this, as in exposing it I shall be paving the way for the correct understanding of the century's achievement in the several departments of art.

The fallacy in question is the proposition : that the nineteenth century was an age of science, and that —or that *therefore*—it was not an age of art ; or, in other words, that the remarkable achievements of science have entirely dwarfed those of art.

This hasty generalisation is in great part due to the very artistic instinct upon which I have just been dwelling—or, rather,—to a trespassing of that instinct upon the scientific instinct. For, let me remind you that, though we are to-day dealing with art, we are emphatically doing this in the scientific or critical spirit ; and it is our desire to apprehend clearly and soberly the relation between the phenomena of our subject in just that spirit in which the mathematician or the biologist endeavours to be scientific in dealing

with his data. Now, the misuse of this artistic sense is responsible for a whole group of fallacies. It leads, when truth is concerned, to inaccuracy, to subjectivity of judgment, to the intrusion of the personal equation. As so often " the wish is father to the thought," so the predominance and tyranny of the artistic sense lead us to seek, to find, and often to create, " harmony" in outer phenomena where no such harmony exists. In our description of phenomena and our account of events our desire for symmetry and harmony, for composition, plays us many tricks when we ought to be accurate. A lady once described this tendency to me in an admirably neat phrase : *Enjoliver n'est pas mentir.* Most of the wonderful *psychical* phenomena and ghost stories are dependent for their wonder upon this tendency, or upon coincidence. To cut off a sharp and ungainly corner here, to add a slight roundness there, to extend or to curtail an interval into coincidence—these are habits of the human mind so insidiously tyrannical, that I have rarely come across even truthful and trained minds in whom I should not feel forced to make allowances for these tendencies when weighing their statements in the accurate balance of truth.

The artistic desire for grouping, for composition, is directed by the fundamental principles of decoration—similarity and contrast, resulting in a just balance. The simplest form of grouping by similarity is in pairs. Now, as in every respectable drawing-room there must be a statuette on either side of the clock

occupying the centre of the mantelpiece, so our great men must be forced into pairs: Shakespeare and Milton, or Goethe and Schiller, or Beethoven and Mozart, etc., etc. And this grouping in pairs, by its constant repetition and repercussion, gently and quite unconsciously fixes in our mind some form of belief or conviction that the types thus grouped are of equal character, merit or standing, and that there is some essential similarity of achievement between them. Now I deny that such a similarity of mental or artistic plane exists between the great men just enumerated: Goethe comes much nearer to being the genius corresponding to Shakespeare than does Milton, Bach stands nearer to Beethoven than Mozart, and so forth.

If this fallacious grouping by similarity is mischievous, it is harmless when compared with unsound grouping by contrast. It is, perhaps unconsciously, our hope that the establishment of such contrasts ultimately leads to equipoise or harmony. This leads us to counteract praise by blame; never to love or admire one thing without hating, despising, or depreciating another: if a person is good, he probably is a fool, if he is good at one thing he must be bad at another; he who loves many cannot love one intensely. These and their like are familiar propositions.

So in the case of science and art, it is supposed that the one cannot advance without the retrogression of the other; that an age is either an age of science

or an age of art, an age of action or an age of contemplation. But in all such generalisations we forget the essential difference between the *organic* and the *mechanical*, between mind and matter. Human beings and the human mind are highly complex organic entities, and their functions, capabilities and potentialities are not to be measured by drapers' yard-measures or chemists' scales. A great man and a great mind are likely (so far as time and vital power permit them) to be great on every side; while normality and sanity, health of mind as well as of body, are most likely to be maintained by the harmonious exercise and development of every faculty and member constituting that complex organism. The emotional as well as the intellectual, the analytical as well as the imaginative faculties are likely to be big and strong in a big man; and, in spite of the necessity of concentration and specialisation imposed by time and physical power as a whole, that vital force cannot be maintained healthy and efficient unless every side of the organism is developed in proportion. Shakespeare and Goethe give the most striking evidence of this.

If the individual man is thus a complex organism, a nation or an age, which comprises large numbers of such individuals, is still greater. If an age or a nation is to be normal, there will be individuals representing all sides of activity, though all may have a stamp and quality which the careful student may recognise as characteristic of that age and that

nationality. If it be a great age it is likely to produce great people, great in many different things.

The achievement of Plato and Aristotle was as great in science as that of Phidias and Sophocles was in the dominion of art. The same must be said of the leaders of the Renaissance. The same can be said of the nineteenth century. It is emphatically untrue that the achievement of the nineteenth century has been less in art than in science.

It is perhaps true that the special forms of artistic expression and presentation may differ in the various ages. In science this is undoubtedly the case. The epic form of poetic expression in the Homeric and Hesiodic poems predominated in the early age of Greece, and was practically abandoned when dramatic and lyric poetry reigned supreme after Aeschylus and Pindar had struck a new key of artistic expression. The great achievement in metaphysics, due to the predominance of the deductive methods of the eighteenth century, has given way to another aspect of scientific method in the inductive spirit of science of the nineteenth century. One rich mine of science or of art may be worked out, and fail to bring returns adequately important or immediate in the eyes of a young generation. It may fail to stimulate mental exertion; or its supersession may even be the result of the change of intellectual habit called fashion. But the new forms, though they may differ from the old, are still the adequate and complete expression of the scientific, as well as the artistic, needs of each age.

We must therefore look to such new forms if we wish to gain an estimate of the scientific or artistic achievement of an age, and not compare its products in a form which it has abandoned with those of a preceding age when that particular form flourished. Music and Prose Fiction (the novel) are adequate and representative types of the artistic spirit and of artistic expression,—they are perhaps the form of art most characteristic of, certainly most highly cultivated in, the immediate past. I venture to say that in no age have these found such supreme and perfect expression as in the nineteenth century ; and we must put them in the forefront of our field of observation when we wish to gain an estimate of the achievement in art of that age. Still, I hope to make you realise that in other forms as well, even those in which previous ages shone most brilliantly, the activity of the nineteenth century reaches a high, and certainly a most characteristic, plane of achievement.

The more intimately I have studied this wide range of subjects the more stupendous has the artistic activity of the nineteenth century appeared to me, the more confusing, the more overwhelming in its hugeness. The task of reviewing it in a single lecture, indeed, began to loom so large before me that I was on the point of giving it up in despair. I was reminded in my depression of a humorous remark made to me many years ago (it was in 1886, just after

Mr Gladstone's Irish Land Bill) by an Irish colleague.
I had just arrived in Trinity College, Dublin, to give
a few lectures (not on politics) when my friend said:
"Have you come to study the Irish question? For
if you have, and you want to talk and write about
it, go back at once. If you stay here a week, you
will see that it requires all your brains and energy;
if you stay here a month, you will be entirely con-
fused; and if you study it for a year, you will give it
up as a bad job. So go back at once and talk and
write about it." Well, I passed through the stages
humorously defined by my friend in regard to the ques-
tion before us, and I felt much inclined to follow the
advice of "giving it up as a bad job"—without "talk-
ing and writing about it." Gradually, however, there
came light. Out of this confusion, this chaos of
subjects, of conflicting tendencies and modes of ex-
pression, one central idea, one point of view emerged,
from the clear heights of which, I venture to believe,
the essential characteristics, the real achievements of
the nineteenth century in the domain of art become
intelligible. Viewing the whole question from that
standpoint, the trend of the whole movement becomes
clearly manifest, and we can realise the stupendous
importance of the advance made. All this is attained
when once we recognise that *the nineteenth century was
the Age of Artistic Expansion.*

II. THE AGE OF EXPANSION IN ART.

THE task which the nineteenth century found before it, the problem which the eighteenth century left its successor, was the expansion of the artistic realm, the extension of its sway over nature and the human mind. This movement towards expansion manifests itself in two different directions:

(*a*) The expansion of the subject-matter of art, and

(*b*) The expansion of the mode and vehicle of artistic expression—both the "what" and the "how."

(*a*) *Expansion of the Subject-Matter of Art.*

The expansion as regards the subject-matter manifests itself in that there is a revolt against the conventional restrictions, imposed by design or by the tyranny of custom and tradition, upon the artist's choice of subjects suitable for artistic expression and treatment. The elevation of mood and the formality of utterance connected with the work of art seemed to draw a halo of sanctity round the spheres dedicated to the Muses, and, as real life and its simple narrative are not suited to rhetoric, so a principle of "aristocratic" selection seemed to govern the artist's choice.

These barriers the new age felt must be torn down; nothing human was to be foreign to the true artist,—nay, more than that, nothing natural. The artist thus gazed out upon the world with a new vision and expanded his sphere of activity on every side.

First, as regards the world without, Nature in the art of the nineteenth century presents itself, and is reproduced in art, in quite a new spirit,—Nature is contemplated in its own right, as distinct from man; its intrinsic interest is freed from, and not necessarily associated with, man's needs and desires, thoughts and sentiments; we find a Nature, unclassical, unromantic, and not merely a setting for human portraits or scenes of human life[1]. This new departure, foreshadowed and prepared during preceding ages by isolated innovators in the domain of art, found its most direct expression in the development of landscape painting, which has been carried on in the nineteenth century in a manner and to a degree unknown to previous generations. But it has made itself felt in all the other arts as well; in poetry and prose-writing, in sculpture and architecture and decoration—even in music; while most of all it has affected the artistic attitude of the observer who is not an art-producer. And when artists and writers state and overstate the doctrine of Truth in Art as all sufficient, sometimes with a confusion of the functions of art and science, it is in reality this emancipation of Nature standing in its own right as a subject of art which

[1] See the *Work of John Ruskin* by the present writer, pp. 62 ff.

they have in mind and the insistence upon which leads to their confused reasoning and statements.

In the second place, the same expansion manifests itself as regards Life, the life of individuals, the life of classes, the life of nations. Up to the middle of the eighteenth century art had not taken direct account of all aspects of human life as such—there had been here also some principle of "aristocratic" selection by means of which heroic life was separated from common life. All manifestations of the soul were rearranged in groups of material suitable for art. In painting, it is true, Rembrandt and the Dutch painters, the Spanish painters and even the later Bolognese, led the way in the direction foreshadowed by the early Flemings and the German artists of the school of Dürer, and dealt with humble aspects of life. But, though many exceptions can be cited, it was generally more from the interest in the "picturesque" or the comic than from the vital artistic feeling for human life as such, that the "aristocratic" principle in art selection was abandoned. In most cases, however, there was a manifest consciousness of condescension. This led to what is called *genre*. For the humbler life was made presentable in the garb of Dresden china shepherds and shepherdesses, pastoral plays or songs which smack of the court or the boudoir. It is this artificiality, and consciousness of light playfulness and condescension, this speaking or writing or drawing or singing in quotation marks, which is an essential characteristic of what is called *genre*.

The current of modern art, however, has carried the mind of the nineteenth century on in a powerful and irresistible rush to all domains, near and remote, into all roads, wide and public or narrow and tortuous, of human life and the human heart : not only the broad, lasting traits of character and incident and presentment, but the minutest manifestations of the heart and mind, discovered by careful psychological analysis, or gained by microscopic observation of the beings among whom we live ; and these beings are seen in their natural setting as affected by their surroundings or striving to shape them. These are all made the material for great art. They are seen by the painter, they are overheard by the poet or novelist—nay, their most individual moods are manifested in the world of musical sound.

The mention of the surroundings of the individual as they affect his inner and outer life brings us to the question of larger groups of individuals or classes. Here we meet with the same expansion of subject. Classes as such become a matter of artistic interest. There is no choice between them, none are too mean or too "uninteresting"; the rich and the poor, the rulers and the ruled, the capitalist and the labourer, the merchant, tradesman and clerk, the landlord, the farmer and the farm-labourer—all, down to the most minute and intimate aspects of their life, have become matter for artistic presentation. And these classes and groups are not stereotyped and made "classical," but are presented in the aggregate under the influence

of passing fashions, customs, traditions and insti-
tutions which sway or direct their course and give a
peculiar stamp to their corporate life.

The characteristics of such classes, with the ques-
tions of the day which these create or suggest, are
made the central topic of artistic interest by an Ibsen
or an Anatole France and by scores of other artists in
other spheres of work. But, further, the artistic interest
expands and makes a matter of aesthetic contempla-
tion out of *national* life.

The discovery of the New World gave a powerful
stimulus to the intellectual life of the Renaissance ;
it widened out man's mental prospect as it enlarged
the horizon-line of the earth on which he dwells.
But its influence was indirect, it affected the mind as
a whole. It is only in our age that the fruits of these
seeds of expansion are reaped, that the life of distant
countries has in itself—by its own right—become a
part of our conscious existence.

Still more is this the case as regards *national* life.
In the Middle Ages there was practically but one
nation of literate people (as there was one language—
Latin), and different national characteristics did not
come within the ken of each separate nation. After
that, down to our days, there was no interest felt by
one nation in the artistic contemplation of the national
characteristics of the other ; and though, as regards
the facts of life and living, national distinctions have
grown less and less in our time (in spite of the tem-
porary recrudescence of Chauvinism, from which we

have been suffering so acutely), the interest in the recognition and contemplation of national characteristics has only begun in the nineteenth century, and is one of the most marked features of its art. This would appear paradoxical if it were not a logical consequence of social development (and one which it might be wise for practical politicians to remember), that subjects and institutions only become material for artistic interest and treatment when they have lost their active vitality or the destructive virulence of their sway, and that the best means of counteracting such virulence is to encourage the theoretical aspects.

In the eighteenth century the life of regions remote and comparatively unknown formed the subject of literature. But these were seen through the wonder-loving eyes of a Robinson Crusoe or Paul and Virginia. A transition from this spirit to that of modern times is furnished by the types created by Fenimore Cooper. But it is not so much the pleasures of wonder as those of understanding that are appealed to in that rich mine of art furnished by the national life of peoples and communities which the nineteenth century has discovered and worked with much profit. Just as the individual life and the individual soul had become matters of artistic interest in every aspect, so every phase of national life, civilised or uncivilised, has made successful appeal to a taste in which the national flavour, the "national-psychology," is the object of keen artistic interest. Imagine the wealth of possible subjects, the expansion of the artistic

domain thereby furnished to the writers of the nineteenth century, who, for all that, sometimes gave utterance to the complaint that their artistic material is insufficient for their needs. They forget the injunction of Goethe, eternally true[1] :

> *" Greift nur hinein in 's volle Menschenleben!*
> *Ein jeder lebt 's, nicht vielen ist 's bekannt*
> *Und wo ihr 's packt da ist 's interessant."*

But the artist's domain has had further accretions ; it is widened out still further, not in space, but in time. The acquisition of the Historical Sense has presented the past to the peoples of the nineteenth century as it never appeared to the peoples of previous ages[2]. The past is not dwelt upon by us because it is an object of *wonder* ; it is not dwelt upon in the spirit of "aristocratic" selection for its heroism or its classicism ; it is not chosen because a part of its life happens to coincide with vital interests of the present ; it is not chosen by men weary of the present because it affords an escape from their prosaic and distasteful surroundings. Rather it appeals, through sympathetic understanding, to the emotions of artistic contemplation ;

[1] This has been expressed by great artists in all times; as for instance Pliny (*N. H.* xxxiv. 61) reports of the Greek sculptor Lysippus : " cum enim interrogatum, quam sequeretur antecedentium, dixisse, *monstrata hominum multitudine, naturam ipsam imitandum esse non artificem.*"

[2] The Graeco-Roman and Alexandrian periods of classical antiquity did approach this historical view. But the past meant chiefly their own national past and relied on this fact for much of its interest ; while it had a strong admixture of the "Romantic" as well as the Grammarian's spirit, which does not develop the historical sense in its purity.

like the life of the individual, the class, and the nation, it requires no selection (for it has selected itself in the course of time on essential, *i.e.*, artistic principles), and the distinct atmosphere of each epoch and each phase of man's life in the past becomes a source of most delicate and intense artistic delight. Instead of being a refuge from the wearisome present, it becomes itself the present, and is as really our own to hold and enjoy as are the gold and jewels which the miser grasps in his hands.

Lastly the sphere of art has been expanded in that the world of thought and all its shadings—nay, the world of science—have furnished the artist with subjects which, though belonging to science, are observed and rendered in an artistic spirit. But the fact that the artist draws upon the domain of science for his artistic material does not make him a man of science, any more than the fact that a painter introduces a horse into his composition makes him a horse-breeder or a zoologist. The central point of interest, of artistic stimulation and presentment has in recent years often been some aspect of thought or science affecting life. Such topics as those of heredity, of religious belief or criticism, of mysticism or materialism, of social and political theory, of the economic and social position of women, of capital and labour, of prisons and their reforms, of sexual dissoluteness, of drink and of gambling as factors of social disintegration, of neurasthenia and of insanity—all these subjects of thought and of specu-

lation have furnished, not only novelists, but even painters and sculptors with inspiration. And in spite of the outcries (repeated *ad nauseam*) of the hack-critic against the novel with a purpose, and of his assertions that both science and art are profaned by being intermingled, the unquestionable fact remains that many a great work of art *has* been produced in the nineteenth century in which some scientific fact or theory has been manifestly the inspiring agency of the whole. And I venture to believe that, as a serious and scientific habit of mind becomes a more natural possession of the human race, such subjects will attract more interest and gain an easier hearing, because they will be felt to be real facts of life ; and life after all will always be the source from which art will flow. The fact remains that this incursion of art into the domain of thought is a striking evidence of the general expansion which I maintain to be the chief characteristic of the nineteenth century.

Before leaving this topic I should like to refer to another side on which the sphere of art-subjects has been widened. The artist of former days addressed himself to a normal or average or high spectator and audience. In our times the point of view upon which the spectator stands has also been taken into consideration, as modifying essentially the choice of subject as well as its treatment. Classes of people, who in former days were hardly considered as possible appreciators of the work the artist produced, have in our time modified extant aspects of art-production,

and even generated fresh ones. I would merely remind you—the train of thought you can elaborate for yourselves—of the rich field of art-production cultivated by powerful or refined artists in special behoof of children, whether it be in books and drawings like *Alice in Wonderland*, or in the works of Walter Crane and Kate Greenaway, or in the *Kinderscenen* of Schumann.

I hope I have said enough to make you realise the existence of a great wave of expansion as regards the subject-matter of art. The same characteristic of the nineteenth century manifests itself when we consider

(b) *The Expansion of the Mode and Vehicle of Expression in Art.*

The expansion of the field of art as regards subject naturally demands a corresponding widening and diversification of the possibilities of artistic expression. Things before unexpressed could not always be conveyed by the means of communication which served for a narrower range of subjects and ideas. The same general opposition and revolt against the trammels of conventionality and stereotyped habit which we noticed in respect of the artist's conception of Nature, Life, and Thought, the same impatient reluctance to be cramped and tied down in his choice of subject

and ideas, are felt by him as regards the realisation of ideas, the presentation of subjects. How, for instance, could the musician rest content with the few recognised set forms of musical composition, stereotyped and become "classical," with instruments incapable of rendering the combination of sounds demanded by the greater comprehensiveness and differentiation of emotion and of thought?

We observe, therefore, in the nineteenth century the pressing demand for a freer, a more extensive, and a more accurate vocabulary, extensions and innovations in the use of form, line, colour, of rhythm and lyrical harmony, of metre and rhyme. Even in the sphere of lyrical poetry there is manifested a struggle for new forms not recognised within the standards of classical prosody ; while prose and poetry are joined in a lyrical form of prose, passionate, rhetorical prose. The development of the pianoforte and its speedy popularity among all classes of society lead to a development of new harmonies, and new forms of complicated music are readily established and made universal. Music is more closely wedded with thought and word, and from Program-Music we advance to truly dramatic music, and even to the *Allkunst* of Wagner.

In painting and sculpture and decoration the same struggle for expansion exists. New methods, new points of departure for artistic expression, constantly present themselves, assert themselves loudly or with quiet persistence : some remain, others pass away and

are superseded by others. Experiments are made, sometimes successful, sometimes not, sometimes the ephemeral fashion of a day, sometimes of enduring merit. They at least show the vitality of art in this direction, the pressing and effective impulse to gain newer and wider modes of expression.

These arise out of the new spirit of the age and more directly out of new forms of life and the new mode of living of modern peoples in the privacy and domesticity of their homes as well as in the active whirl of public intercourse. The change in the fun-damental and material conditions of living effected in the nineteenth century is so absolute that all art which reflects the spirit as well as the facts of national life is bound to seek for and to find wider and more varied forms of expression than those that sufficed for the conditions of previous ages.

Let me suggest but a few of these: No doubt printing was discovered in the fifteenth century; but it has only been put to its full use in the nineteenth. Before our age newspapers, periodicals and books were—one may say without exaggeration—limited in their appeal to a restricted class of the learned or the wealthy. The nineteenth century marks the expan-sion of their use among all grades of civilised society. Whether or no this expansion immediately results in the elevation and spread of art in its highest forms is a debatable question. But that it has an imme-diate effect upon the inner nature of literature as well as upon the modes of literary expression is undoubted.

I shall have more to say later about the direct
effect upon the graphic and pictorial arts caused by
the introduction of new processes[1] for the rendering
of colour and design in original as well as in repro-
ductive drawing and painting; but to illustrate the
effects of the change in the material conditions of life,
let me but mention a few facts out of many. Take the
influence of our illustrated papers and even of street
advertisements upon the expressive power of graphic
art. Consider for a moment the strain put upon the
draftsman, the engraver and the printer by the pressing
demand to satisfy these needs of actual life in artistic
forms. Let me further ask you to realise the pressure
brought to bear upon the inventiveness and ingenuity
of the architects to build the new railway stations and
exhibition buildings serving new purposes and re-
quiring the use of new materials. Remember the new
kinds of music required for the various forms of public
concerts, musical festivals, popular open-air perform-
ances, military bands, etc., and the fact that music
penetrates not into a few homes, but into thousands.
Consider all this, and you will realise the necessity
under which the artist finds himself to discover new

[1] As this is going to press the correspondent of the *Times* in
Paris reports on the important discovery of a method of " solidify-
ing oil-colours into cylindrical sticks resembling pastels, so that
painters in oil may henceforth dispense with the paint-brush and the
palette." This discovery made by M. J. F. Raffaelli, should it
prevail, may revolutionise the art of painting. Titian's exclamation
is quoted: "Oh, if only we might paint with colours that we hold
in our hands!"

forms of expression which will satisfy new needs and a new public.

I know "romanticists" will protest against the prostitution of sacred arts to such low uses. And, for a time, I admit, all expansion, all breaking loose from established laws and canons is likely to produce a temporary retrogression, a tendency towards the vulgar. But I would remind the "romanticist," the worshipper of the past because it is the past, that, in the same breath with which he will thus violently condemn the degradation of art by its application to low uses, he will extol in the past the immediateness and sincerity with which art was related to the daily life of ancient peoples. " In the glorious past," he will say, " even the smallest and apparently the humblest objects of life had art to refine them." And he will collect the fly-sheets and broadsides and coarsely printed songs of a bygone age which, after all, compared with some beautiful advertisement-sheets I have recently seen, are as the unbaked bowl of the savage is to a Greek vase.

It is important at this stage that I should remind such a "romanticist" that the older forms and achievements in art are for the most part still in use, and that these newer forms are an addition to our artistic *repertoire.*

This brings me to the causes of expansion which came from within the artistic sphere, which are not due, I mean, to the influence of ordinary life upon the domain of art. For the artist as well as the art-

appreciating public becomes wearied of the old forms as such, and from age and familiarity these forms fail to give the stimulus and interest necessary for the full reception of the artistic ideas themselves. Then the cry makes itself heard: Is there no new form? Meanwhile the artist himself, from the love of his own technique and the joy he feels in the use of it, is always making experiments, and is unconsciously driven on to the invention of new forms: and this is one of the most effective causes of progress in every department. Sometimes it may be only a caprice, an eccentricity, on the part of the artist or on the part of his masters, the public. But the fact remains that in ages of artistic vitality the motives for inventing forms of expression are constantly and actively at work.

We thus come to the influence of inventions: and it can hardly be denied that the nineteenth century is decidedly an age of invention. Now, much as the spirit of mechanical and physical invention may differ from, nay, in some aspects be opposed to, the artistic spirit, there can be no doubt that, indirectly as well as directly, this spirit and its achievements have an influence upon the expansion of artistic expression. A public in which a newer and more correct recognition of the laws of physics has permeated to the daily consciousness of most people must be modified in its modes of perception and observation. Let me merely remind you that people conversant with the rudimentary laws of physics cannot be satisfied with

the presentation of perspective in drawings and pictures that would have satisfied those not so trained. When the artist himself takes cognizance of the laws of nature, of the laws of physics and mechanics, and when the inventor takes cognizance of the needs of artistic expression, the result is a new departure, a great advance in all artistic technique. I have already mentioned the influence of the pianoforte on musical expression. Realise what the perfection of the pianoforte did, and how it led to the productions of a Chopin, whose works—pianoforte compositions *par excellence*—show the complete fusion of the subject with a peculiar mode of expression. Think of what the absolutely startling improvements of the wind instruments by the brothers Sax meant for the development of orchestration. Consider the problems which the extensive use of iron and steel, and the consequent discovery of its possibilities of stress and strain, suggest to the architect. Recall what the blending of metals and their alloys, the development in the forms and uses of glass combined with metals and other materials, the elaboration and variety of structure and form suggested by the diversity of products in the manufacture of bricks and tiles—what all this means to the decorative artist. Let me merely, to illustrate my meaning, single out one discovery of the nineteenth century in its bearing upon the graphic arts, I mean photography. Consider how the public as well as the artist must regard the truthful rendering

of objects of nature in pictures and drawings when they have become thoroughly conversant with their rendering in photographs from childhood upwards. Recall the change which has imperceptibly crept into our appreciation of motion through the discovery of instantaneous photography and the manner in which it has affected the artists who represent such motion in animal or in man. I do not mean to say that such direct influence will ultimately maintain itself. For we must not forget that the perceiving eye of man makes a broader synthesis of instantaneous units of motion, and that the instantaneous photograph may be artistically as untrue as the application of a microscope to the human skin would be misleading for the artistic rendering of the texture of the nude. But what I wish to illustrate is the undoubted effect upon graphic expression caused by such an invention, both in the artist who produces and the public who appreciate his production. Nor is it reasonable to think that the effect of photography upon art must only be in the direction of a literalness in the rendering of detail which might in its effect be destructive of artistic principles. On the contrary, the effect of photography in this direction may intensify the need for the artistic function in a broader and more imaginative rendering of the aspects of life and nature; and it is a significant fact that, in the period of the most marked advance in the use of the camera, the impressionist school of painting and drawing has come most prominently to the foreground.

Finally, I would suggest as another cause of expansion in artistic expression, the influence of the historical sense to which I have referred before. For, what I have said of this historical sense and of our possession of the past with regard to subject-matter, applies also with regard to artistic expression. Besides our acquisition of new forms we retain, nay, we *revive*, the older forms of technique. We are often not able to reproduce them in the fulness of their quality, though a good deal of conscious endeavour was turned in this direction in the latter half of the nineteenth century, and is active among us now. But again I say that this is not done in the spirit of romanticism, merely because these works are past and not present ; it is done because the works produced appeal to a faculty, singularly and distinctively our own in modern times, the faculty of enjoying the atmosphere and flavour of each period of bygone history : for every such period becomes in its individuality as real to us as the forms of nature about us which we observe, admire, and reproduce. Nay, this sense goes so far that we have even reproduced deficiencies which mark the incapacity of the technical workers of former days in order the more fully to render and to enjoy the historical flavour of each age. This increase of technical modes of expression is further enlarged by the introduction of technique from foreign and distant lands, which we study and appreciate in the same objective spirit,—lands of whose existence the precursors of the nineteenth century were hardly aware.

The main point, then, which I wish to bring home to you, and desire now further to illustrate by a cursory glance at the several arts in detail, is this characteristic of expansion in art; I hope that from it you will further gain the conviction, which I strongly hold, that the nineteenth century is as remarkable for its artistic achievement as it is for the advance made in science.

III. THE LITERARY ARTS.

In literature as in the other arts the writer aims at producing aesthetic pleasure through the human senses, through the imagination and through the deeper faculties of the heart and mind, language being used by him not merely as the vehicle of imparting facts, but as a material which in his hands acquires form, and thus responds to man's fundamental need for harmony.

The eighteenth century bequeathed to the nineteenth the beginnings of the great struggle between the two great factions of literature, the strife between the Classic and the Romantic. I may at once say that the evolution of art in all times shows this same struggle. For it is a struggle between form and life, between idealism and realism, between beauty and truth, or whatever other names are for the time given to the two great component elements of all art. All criticism may be shown ultimately to turn round the balancing of these two elements. I must leave you to think this out for yourselves. But, meanwhile, I must endeavour to clear up the great confusion which arises out of the vague and vacillating use to

which the terms Classicism and Romanticism have
been put. For the text-books on criticism, on litera-
ture, on music, and on all arts, use these terms in
a manner which seems to me most confusing. What-
ever these terms may be held to signify on the
ground of the etymology of the words, or of the
meaning assigned to them by writers of authority, it
appears to me that, especially as applied to literature,
the best guide to their meaning is to be derived from
the adjectival forms, classical or romantic. We all
have a more or less distinct idea of what we mean
when we call a face, or an author, or a piece of music,
classical ; or when we speak of scenery, or a person,
or a mood, as romantic. With regard to the term
classical, it is often used to signify qualities ap-
pertaining to, or possessed by, the ancient Greeks
and Romans. This is a narrow and an accidental
meaning. But it has some justification. For those
qualities of the Hellenic past which have survived,
and upon which our canons of taste are chiefly based,
are those which make a thing "classical" in all times.
They are the catholic canons of form based upon
the study of nature and man's senses which have
gained universal and lasting recognition. And thus
the word classical in its wider acceptation is used
for those subjects of art which manifest the fully
established and the fully recognised forms. Romanti-
cism, on the other hand, may in the first instance
mean the opposition and the revolt against this
classicism in so far as it was established, known and

recognised. And it thus came to denote the search after the unknown and the opposition to the powers that are. In the eighteenth century Romanticism grew out of a misunderstanding of the essential nature of Hellenism. And thus, so far from representing the struggle of life against form, it represented the struggle of sentiment and of extraordinary forms of life against the true and lasting principles of life in art. For the essence of Hellenism is that it represents nature, sanity and rationality idealised, generalised to its highest form. Hence comes its power of persistence in all times and amid all changes of taste.

The Italian Renaissance of the fourteenth and fifteenth centuries was in reality a regeneration of man in his natural sane vigour and power. In the domain of art its sons raised the cry: "Back to nature." Man's feeling for form, which had until then been restricted for its satisfaction to the conventional on the one hand or to the grotesque on the other, was led back to nature pure and true, yet raised by art to the spheres of harmony which are lasting and valid : and this is the true function of Hellenic idealism. Yet in the seventeenth and eighteenth centuries this Hellenic spirit of the Renaissance loses its true vitality and significance; the classical becomes stereotyped and conventionalised down to the eccentric, the affected and artificial ; and the term classic came to stand for that which was universally adopted by rulers of the time, and signified

an art academic alike in subject and in expression.
Form became formalism, killing or hiding nature.
The "classicism" of the seventeenth and eighteenth
centuries is in its main features directly opposed to the
essence of Hellenism. The fullest expression of this
is to be found in the France of Louis XIV. and his
successors, in Versailles with its Trianon and all its
dainty affectations, with its Dresden china shepherds
and shepherdesses reflecting the attenuated and
emasculate forms of the Romanised Hellenism of the
decadent classical world. Even the dramas of the
great geniuses Racine and Corneille are pervaded by
this formalistic classicism, diluted by the servile spirit
of a Court akin to it in its artificiality and affectation.
It is against this un-Hellenic tyranny of classicism,
this caricature of the Hellenic, against the Greek gods
in periwigs and with the red heels of noble birth, that
Lessing fulminates ; and it is against this spirit that
Rousseau and the romanticists grouping round him
revolt. But this revolt leads to flight, flight to other
regions and other times ; and thus the romanticist is
led to distant imaginary regions of fictitious savage
life or back to the mediaeval life : away from the
familiar present to the Middle Ages or to nature "in
her most pleasingly awful aspects" as the phrase
went, not, remember, the familiar nature around him.
Both the classicism and the romanticism of the ages
preceding our own have as a common and chief
characteristic the tendency to be removed from the
present and actual ; and so, in both, art is divorced

from life. What attracts the romanticist in mediaeval-
ism is but one side: its "savagery," its "grotesque-
ness,"—the mediaeval, strange to say, from which two
centuries before the Renaissance had brought man
back to nature. Lessing felt that what was needed
was a real understanding of the nature of the Hellen-
ism which in its art, its literature, its philosophy, and
religion even, had always kept in touch with nature
and with the actual life of the people, however
high its flights into ideal spheres; and through this
Hellenism modern art was to be brought back to
nature and the life of the present.

Yet this was not achieved in the eighteenth century
(though its consummation was then prepared), but in
the nineteenth, and thus in the nineteenth century also
there has been another true renaissance in which the
genuine Hellenic and the Greek language have super-
seded the later forms derived through the Roman and
the Latin. As Lessing thus holds up Greek literature
and art in one hand, he points with the other to the
literature of England which was the first, in subject
as well as in form, to break through the narrow limits
of formalised classicism and of artificial romanticism.

For while, a generation after Lessing's death, the
great leader of romanticism throughout Europe, Byron
(in the form and spirit of whose works the elements of
the new age are nevertheless often to be discerned),
kept the flame of romanticism alive, the beginnings of
the new spirit of expansion are found in England in
the novelists of the eighteenth century. Lessing points

to "Clarissa Harlowe" published in 1749. This was followed by "Sir Charles Grandison" in 1753, and then come Fielding and Smollett and Sterne and Goldsmith in rapid succession. In an unbroken progression these novelists draw literature nearer to actual life, extend the sphere of subject and material and the freedom and diversity of treatment, until we come to the full establishment of the modern novel with Jane Austen. She stands at the head of a wonderful series of writers, with Dickens and Thackeray and George Eliot as chief luminaries. On them follows a long line from which I can single out a few names, while most of these artists are, fortunately, still among us: George Meredith and Henry James; Bret Harte, Kipling and Mark Twain; Hardy and George Moore and Mrs Humphry Ward, and Frank Norris who passed away quite recently before his vigour and originality could carry him through the discipleship to Zola to the mastership of which his early writings give promise. There is a host of others whom I cannot and need not mention. Consider for yourselves how the different characters of these writers, the variety of subjects which they treat, the multiplicity of forms in which they put their art, illustrate the expansion in subject and matter, of which I gave you a general account at the earlier part of this lecture. They enter into every aspect of life in every class, and thus expanding their work in artistic interest they touch with loving delineation upon religion and thought as essential elements in life, and bring home to us the social struggles and the

social problems which move our times. I for one am astounded at the number of remarkable books produced every year, books that a hundred or even fifty years ago would have been discussed for years by the thoughtful and critical. If I were challenged, I could single out many works that seem to me lasting types of literature which, for all that, hardly succeed in rising above the horizon and never penetrate into the domain of popularity. Who of you, I may ask, has read Mr Conrad's[1] "Lord Jim," to my mind a most notable and original work, presenting a real "soul's tragedy"? I am grieved to think how many works of eminence and distinction are produced in our time which really stand in grave danger of being forgotten. We need not and we ought not to tread in the footsteps of narrow "classicists," who constantly point to the great genius of a Dickens and a Thackeray and a George Eliot, whom we esteem as much as they do. Our own period has given birth to a new and valuable type of fiction in the short story established by Bret Harte and brought to perfection by Rudyard Kipling, in which a central idea or situation is brought home in a new and concentrated form of literary composition. It has produced in literature big national, nay more than national, human types which deserve to be called classical in their strength of presentation—such as

[1] As this is going to press, I am gratified to find that Mr Hugh Clifford, in an article on "The Art of Mr Joseph Conrad" in the *Spectator* (Nov. 29, 1902), does full justice to this remarkable writer.

George Meredith has portrayed. It reflects the most complex and subtle relation between living individual characters and the social conditions out of which they grow or with which they battle. This has been done, for instance, by Mr Henry James, who at the same time establishes a new method of objective delineation. Such a period as this, then, need not turn in despair to the bygone luminaries of even the middle of the nineteenth century.

In Germany the romantic spirit maintained its sway perhaps longer than elsewhere, especially in forms of prose fiction. And yet the giant Goethe, who towers above the world as a type of supreme sanity and versatility, clearly felt the advent of the new spirit, and did his share in opening the way for the advance of the new forms of prose fiction in his "Wilhelm Meister" and in "Wahlverwandtschaften." And though his "Werther's Leiden" is the type of all that is romantic in sentiment, it is in a way the first instance of introspective psychology in fiction. Heine, too, who with the fatal germs of paralysis eating into his health and spirits is dragging his numbed feet out of the clinging soil of romanticism, shows his clear head with the deep and lucid eyes and the kindly smile lurking beneath his sneer, and is peering into the new age and straining into the distant future. So too the wonderful story-tellers of the Gutzkow type manifest a blending of romanticism with the vigorous feeling for modern life. Among all German writers, however, there is one comparatively unknown,

even in his own country, who in a most remarkable degree anticipated in the first half of the nineteenth century the development which prose fiction underwent in the second half. I mean Otto Ludwig. In his novel "Zwischen Himmel und Erde" he has given a most masterly study of domestic life and character in a German town, which will hold its own with any of the masterpieces written during that period or in subsequent years in other countries of Europe. But I think I am right in saying that in the development of prose fiction and of the drama (perhaps with the exception of the highly original works of Gerhard Hauptmann), Germany owes its chief impulse and direction to the contemporary rise of French and of English literature. As in so many other spheres, so in that of literature and the graphic arts, France has done pioneer work and can in this respect share the honours with England.

I feel tempted to venture upon a generalisation as to the distinctive characteristics of England and of France in their effect upon the development of intellectual progress in the civilised world. Whereas we in England often do things without knowing it, and still more often without saying it, the French become intelligently conscious of the movement to which they are contributing. They formulate it, and struggle and fight for the idea and the principle which their productions imply and illustrate. Lessing had to tell us what our eighteenth century novelists represented in the development of literature. Owing to the tempera-

ment of the English people it is often unwise and impolitic to manifest the fact that what one is doing is new and establishes a new, though progressive, principle. The Frenchman, on the other hand, shows his own courage and the intelligent generosity of the people whom he addresses, in proclaiming from the housetops the new steps he is about to take and the justice and desirability of such an advance. This open proclamation on his part is likely to gather support and to evoke sympathy, where in England it would create mistrust and opposition.

Though France can boast the possession of the last leader of the romantic school, perhaps the greatest of them all, namely Victor Hugo, it can also claim to possess the first of the specifically modern writers of fiction who has opened the gates to the spirit of expansion in subject and in form, the prevalence of which in the nineteenth century I have hitherto endeavoured to impress upon you. There is no line in prose literature during the second half of the nineteenth century that is not foreshadowed in the stupendous work of Balzac. Life, life in all its manifestations, in the metropolis and in the distant provinces, and through all layers of society within the nation, characters in all their natural and morbid developments are treated with a frankness, a perspicacity and a sense of artistic presentation which make this great author a classic in the truest sense of that term : while at the same time he is a pioneer in the march of artistic expansion. This determined incursion

of the highest literary art into the depths of the actual life about us is carried on with vigour and supreme artistic skill by Flaubert, and the current of this impulse is swelled by the tributary support of great writers such as Stendhal and Gautier. So swift and impetuous is the stream that we must not be astonished if the banks of life, through which it forces its widening way, contribute some of their polluting elements to the clear current. Yet, say what one will, Zola and Guy de Maupassant have fought the battle of expansion as few others have done; and though in their struggle with conventionalism and with a just sense of reticence they may often have gone too far, they stand as great landmarks in the progress of prose fiction. I said "just reticence," for I maintain the justice of the claims of reticence; and I maintain this from an artistic as well as a moral point of view. For literature and art in order to be true need neither be telescopic nor microscopic. Since the artist is forced to select the artistically important attributes in every object he presents—specimens, as it were, because he cannot represent all the myriad attributes equally—the exaggeration of one aspect of life, which in life itself is kept in the background, need not be systematically dragged out into the foreground of artistic composition. On the other hand, the relation between man and woman is an essential feature in human life; and the problems arising out of it cannot and need not be ignored by art. Allow me to add, as the great novelist and noble fighter has

passed away since I delivered this lecture, that, to my mind, Zola, so far from being a realist, in the usually accepted meaning of that term, has always stood as a pronounced and pure idealist in literary art ; because there is not one of his works which does not embody some dominant idea out of which his work grew and which, as a work of fiction, it illustrates by means of convincing types of people and incidents which we see about us.

Consider for a moment the variety and versatility of French writers within the immediate past, the contemporaries, followers, or opponents in art of the great men I have just mentioned, the boldness of new movements, from a realistic to a mystical atmosphere, from clear chiselled work in detail to the vague and broad suggestiveness of symbolists, —and you cannot fail to be struck by the surging vitality of artistic effort in France alone. Let me but single out as a lasting instance of achievement and success the beautiful work of M. Anatole France, who is still among us. In him, not only is the most familiar life in its confusing proximity to our actual observation and our personal interests lifted to the level of the purest art, but the past too is brought home to us with a directness and vitality in which the linguistic and literary form is completely harmonised with the subject.

If we leave the great nations of Western Europe and America, and turn to the north, we find literary artists who in the boldness of their genius open out

new spheres of life, bring home to us burning questions of social evolution; and this in a form of which the eighteenth century knew nothing. Most of us only know the work of the great Scandinavian writers Ibsen and Bjoernsen; but there are others. I have, for instance, come across a novel by Jacobsen called "Niels Liene[1]" which can claim to be classed with the best modern novels of France and England.

Who again could forget the epoch-making position Russia holds in the development of modern literature, and which future ages will recognise as classical landmarks? Gogol, Tourgenieff (perhaps the most perfect type of a true artist in prose fiction), Tolstoi and Dostoievski, and a host of more recent writers have opened out great vistas of life and nature and have illumined these endless tracts with an artistic light and form specifically their own. Past ages too have been presented, with that historical sense of which I spoke before, in a masterly form of art by Merejkowski, whose pen has produced historical novels never surpassed in their excellence even by the greatest writers of the nineteenth century. Even Poland has contributed to this movement. The work of Sienkiewicz—alike in his earlier historical novels and in his portrayal of contemporary life—is of enduring value. Nor should his predecessor Minkiewicz be forgotten.

[1] I have since heard that this novel has been translated into English under the title *Siren Voices*.

As I pointed out above, these great national pro-
ductions do not appeal only to the sympathy and
the artistic interest of the people among whom they
are written. The whole civilised world not only is
interested in the life of its component parts; but,
what is more, has the capacity for appreciating
these different national characteristics as such. We
are interested in the Russian Mujiks of Gogol or the
sporting squire of Tourgenieff, the Russian types
presented by Tolstoi or Dostoievski; the brilliant
colour of the Hungarian pusta in the works of Maurus
Jokai; the Bavarian and Tyrolese peasants painted
with such vigour by the pen of Rosegger and Anzen-
gruber; we feel the supreme pathos in Emile Franzos'
masterly pictures of the life of the Roumelian Jews;
the weird lights and shadows in the life of the lonely
fishermen of Pierre Loti, in the rude mining camp of
a Bret Harte, and finally in the brilliant mixture of
eastern and western life which Mr Kipling throws on
to his canvas with the facility of genius. All this world
of new artistic material the nineteenth century has
presented to us for the first time.

In poetry the characteristic spirit of the nineteenth
century naturally does not manifest itself to the same
degree. For the established forms of versification, so
highly developed by centuries of human effort, the
exalted mood out of which poetic diction arises and
which it evokes in the hearer have kept poetry within
the realm to which it belonged for all ages. Thus, in
spite of their pronounced individuality and originality,

Shelley and Keats and Tennyson and Swinburne breathe the same atmosphere of poetic inspiration and of poetic form as did the great poets of the past. Yet even these great masters of lyrical harmony mark the tendency towards expansion as regards the realm of subjects, familiar or thoughtful, present or past, reflecting a peaceful acquiescence in established law and order or a restless straining after freedom and the wider capacities of life. And who could fail to see that the spirit of expansion as we recognise it in prose literature has been potently active in Wordsworth; and that this same spirit manifests itself in a still more powerful manner in Browning with his introduction of colloquial phrasing, and his adoption in his lyrical writings of the familiar experiences and thoughts of actual modern life? He brings new spheres into the realm of poetry as he invents new, direct and dramatic forms of poetry which appeal straight to the experience and the sympathy of modern men. In him we see the expansive tendency at work alike in his selection of new subjects, and in his adaptation of the newer developments of learning for the purposes of his poetry. He makes appeal to the widened range of knowledge and of thought which the accessibility of learning brings within reach of modern men. And though he may not always be "poetic" when the standards of form of pure lyrical poetry are applied, his bold incursions into prosody create a new harmony with new and wider ideas which the older prosody could not encompass and

contain. In Kipling's poems both form and matter manifest the same boldness in dealing with the actualities of modern life. In Walt Whitman, finally, we have a significant attempt to throw off the yoke of traditional form and to blend prose and poetry into something which, while it admits of the adequate expression of our life without sacrificing to art a single pulse-beat of vitality, shall at the same time satisfy the lyrical need for harmony. We have not heard the last word as regards such an endeavour. Meanwhile in France, as well as in England, where writers like Maeterlinck have tried to do what Ruskin has achieved in so masterly a manner, prose itself has approached poetry, and has even penetrated to some extent into the boundaries of its sacred domain, in virtue of its harmonious and rhythmical cadences.

When we come to the drama, whatever the intrinsic merit of recent productions may be compared to the monumental works of the greatest dramatists of the past, the same spirit which we have noted in the novel is revealed. The *Bürgerliches Lustspiel* to which Lessing aspired has been developed in the nineteenth century in all its forms. Progress in dramatic individualisation has been active and has produced characters so convincing in their appeal to immediate recognition and sympathy that they will stand out as clear-cut types of the life of the nineteenth century to the men of future ages. The nineteenth century advanced in the clearer indi-

vidualisation, not only of the characters in their varied though typical shadings, but also of the situations, the social setting, and the actual scenic presentation. Individualised presentation in the performance itself, individualised rendering of the definite situation, and the conditions evoking and surrounding the actions and characters, on their part help to impress, to fix and to intensify the delineation of the finer shadings of each character in a play. And here too I believe that the last word has not been spoken : that dramatic art as such can approach still nearer to its peculiar sphere of artistic expression in its widened range of subject-matter by a further development of the perfection of stage arrangements of which the dramatic author himself will take cognisance. I mean stage directions in which, not only the correctness of historical rendering in all accessories is aimed at, but in which all details of the scenery and surroundings shall point and emphasise the definite situation which they illustrate and the individual characters who act in them. Even in the choice of the individual actor the author of the future, in conjunction with the stage-manager, may have to use his selective power to emphasise his delineation by the personal appearance of each actor, in so far as in his stature, face, voice, manner and general appearance, he most fully expresses the individualised type which the author wishes to present. Undeniably the dramatic writers of France, Dumas, Sardou, Pailleron, an Ibsen and a Bjoernsen, a Gerhard Hauptmann

and others, have applied new methods in giving a
wider range of character and of situation, have intro-
duced new subjects and new ideas into the pale of
dramatic art, with a directness in their relation to
the actual life of all classes of society about us, such
as was unknown to the dramatic writers of previous
ages.

IV. MUSIC.

PERHAPS I may be allowed to make a transition from poetry to music, which as an art has undergone the most characteristic development in the nineteenth century, by going into the details of but one sub-division of musical art with regard to form, that is, the song, *das Lied.* At the hands of the great masters of this most pronounced form of lyrical art, Schubert and Schumann and Brahms, the song has received a development at once most perfect and illustrative of the peculiar expansion upon which I have insisted. They have selected the perfect specimens of lyrical poetry, such as those of Heine, and the music to which they have wedded them has harmonised com-pletely with the poem. A new work of art of the highest quality has thus arisen out of the union. The lyrical and personal mood of such poems has been intensified by a more direct appeal to the whole-ness of our emotional nature through the melodious effect of musical harmony ; while the vagueness and the limitation of musical emotion have been made definite and yet widened in scope and in their appeal to human feelings by the incorporation of the words

and thoughts of a great poet. Practically a new art has been created, the potentialities of which have not yet been exhausted. For beyond the merely personal and subjective moods which record the joyful or the sad feelings of the human heart, there lie ranges of lyrical moods not so subjective and not so personal which this new form of art can most fitly express— even the moods evoked by thought and by natural scenery. In some songs of Schubert and of Schumann thoughts not directly human and personal are the motives to the lyrical mood ; while in a few songs of Schumann, such as " A Sunday on the Rhine," the emotion evoked by a definite landscape is transferred or translated into its musical and lyrical equivalent. More recently I can recall such landscape-lyrics— one, describing a day on the lake of Constance— among the works of a composer (hardly known to the public, even in Germany) who died too soon, namely, Brueckler ; while, in a similar sphere, French writers like Fauret and Hahn have carried this new art a stage further.

The detailed study of even such a single branch of the main stem of art is instructive in illustrating our main point. But, speaking generally, who dare deny the stupendous development and expansion of the possibilities of musical art in our time, even though they may feel with us the monumental greatness of a Bach, *aere perennius,* or the peculiar charm in the early Italian masters ? The range of music in bygone days was infinitesimal compared to what the expand-

ing spirit of the nineteenth century has made it in our own times. Either it was limited to the purely formal side, in which, like decorative art appealing to the eye, the absolute harmony of tones appealed to the ear. This is a sphere which will always belong to music, and which has produced works of the highest order. Or music was then the accompaniment of definite acts of man, which it illustrated, emphasised and ennobled ; there was the warlike march, the dance, the dirge, the ritual. This also has led to the production of great works, and this category will still have unlimited scope. Or again it was the immediate artistic expression of the elementary moods of man, the lyrical form. And here it led to the expression of personal emotion, of which the range was practically limited to elementary distinctions of joy and of sadness.

Yet all these subdivisions are elementary when compared with the range which the great masters of the nineteenth century have given to that art.

Stupendous as were the steps in advance made by a Haydn and a Mozart, the new spirit of active expansion which has filled the musical art of the nineteenth century really begins with Beethoven, and that not the Beethoven of the last years of the eighteenth century but the Beethoven of the beginning of the nineteenth. From that moment on, while the older forms survive and are justly cherished and cultivated, their absolute authority pressing on the free inventive genius of composers is denied, and

with a rush the new spirit sweeps through the world
of sound and produces entirely new harmonies. In
Beethoven as a pure musician the expression of
human emotion is widened out to ranges in which,
with an adequate expression, a great and thoughtful
soul has soared beyond the merely joyful or sad into
vast regions, at once so comprehensive and intense,
that at times they verge upon the cosmical. Schubert
and Schumann, and above all Brahms, have been the
direct inheritors of the emancipation of musical art
initiated by Beethoven.

The more, however, the purely formal side of
music, without losing its beauty or its direct appeal to
the aesthetic faculties of man, has thus approached
to man's actual life of feeling and thought, the more
were the efforts of some of the leading musical
geniuses of the nineteenth century directed towards
expanding the province of that art. This has pro-
duced what in one phrase has been called " program-
music": music in which harmonies of sound are not
only meant to appeal to the broader and vaguer
emotions of man, but are to be differentiated and
therefore intensified as emotions, by the introduction of
definite thoughts. To do this the musician may often,
and at first does, require the help of accessories not
specifically musical; because ordinary man does not
think in terms of music. And thus words may be
called in, either as an integral part in the lyrical
or dramatic presentation (as at an early period
Beethoven felt the need of introducing words into

his choral ode of the Ninth Symphony), or in the
form of titles or sub-titles to the several movements.
Words may thus be premised as an accessory frame-
work to the musical picture, as finger-posts, in fact,
for the musical landscape that has to be explored.
As an instance let me but cite two familiar short
musical compositions by Schumann. One is called
"Warum" (Why ?), the other "Leides Ahnung" (Pre-
sentiment of Sorrow). These, by the help of their
titles, present the most subtle and complex moods
and experiences of life in a most definite manner,
and yet with that fulness and directness of emotional
understanding on the part of the hearer, which music
alone can most fully evoke. Imagine the wealth
of subjects opened out to the musical composer
by the addition of this new method to the more
formal ones that the past had given him. And
at the same time realise the new combinations of
tone-effects within the strictly musical spheres of his
art, which such an expansion of the possibilities of
expression have opened out to him. It is as if
a painter had been restricted to the immediate and
direct use of the four elementary colours and of pro-
nounced light and shade, without mixing or blending
them into new combinations, and were then per-
mitted to apply the infinite variety of such combi-
nations to develop his drawing of line and modelling
of form. He is no longer confined to merely de-
corative art: all nature at once becomes his province.

It was with eager joy that the composers of the

nineteenth century plunged into this fresh stream of musical expansion, and through Berlioz and Wagner and Tschaikofsky, and many of their contemporaries and followers, great compositions, great in bulk and calibre as well as in conception and import, were produced. I mention Wagner here, not as the dramatic writer, but as a composer of instrumental music. For I need hardly say that, with this enormous accession of subject-matter and the direct approach in expression to man's life and man's feelings there must have been, as there has been, a corresponding expansion of the means and modes of expression. Instrumentation, orchestration, and vocalisation have been entirely revolutionised ; and effects of sound are now produced which were never heard and never realised by the musicians of previous centuries. These sounds—on the purely aesthetic side—suggest thoughts and feelings the expression of which is entirely new in music. Of whatever school we profess ourselves adherents, and however truly and adequately we may be able to admire the great and "classic" compositions of the old masters, or however responsive we may still remain to the simple and perennial charm of the Folksong and of pure-melody, we must all admit the expanding greatness of the musical achievement of this nineteenth century, the wealth of new effects expressing in themselves and producing in the hearer new qualities of artistic emotions, new suggestions of thoughts and feelings, unheard before this.

And if now we turn to the fusion of music with words and scenic representation, to the history of the opera, who would deny the revolution which has taken place owing to the genius of Wagner? To this stupendous development the remarkable composers of the Italian school during the first half of the century had contributed. But in these writers the dramatic was still subordinate to the lyric. One among them, it must be remembered, passed through nearly every phase of this stupendous advance,— namely, Verdi. But it would not be right to forget the composers who mark only the period of transition, Rossini, Weber, Gounod, and, emphatically, even Meyerbeer.

The struggle which the Wagnerian conception of the opera underwent until it prevailed in the end is too near to us to require exposition by me here. To say the least, in the light of the main point which in this lecture I wish to impress upon you, the combination of the various arts into the one artistic whole called the musical drama marks a new departure. Its component elements, orchestra, soloists, chorus, scenery, and action, some appealing to the ear, others to the eye, have their effects fused together into one whole, which impresses the unity of the drama and produces a new aesthetic effect upon the audience. It will hardly be denied that this meant a stupendous expansion of the subject-matter and the form of musical art. In my own younger days I can well remember Wagner's music being called *Zukunfts Musik*,

the music of the future. It is now, at least in time, the music of the past; and the question arises: is there much chance for a further development of the Wagnerian conception of the musical drama? It must be admitted that, as regards the quality of orchestral music and of instrumentation, in pure music as well as in the complete wedding of harmony and meaning, the impulse given by Wagner is supremely active and will ever remain so as a phase in the evolution of musical art. May I be allowed, however, to express my doubts as to the further development of the Wagnerian musical drama? I feel that, after all, given the approximation of art to life of which I have spoken, the dramatic sphere is to some extent blocked to music, because we do not naturally sing in the usual process of actual life. It is by a correct instinct, fixed by well-balanced thought, that Wagner himself has called his great operas "Romantic Operas," that is, essentially, operas that do not deal with real life. He has again selected (outside the cycle of his mythological subjects) tales in which the action itself was essentially concerned with song, and the action was raised to lyrical spheres, such as the "Meistersinger" and "Tannhäuser," the second title of which is "The Minstrel's War on the Wartburg." But such subjects are distinctly limited in their number. It is interesting to note how, in his graceful, lighter musical drama, Humperdinck has chosen the atmosphere of the children's fairy-tale to justify his dramatic use of pleasing melody. On the

other hand, may I be allowed to add, that this does not imply cessation in the development of program-music; and that, in the sphere of the cantata and, above all, of the melodrama, great possibilities may still be before the musical dramatist? We can conceive the introduction of music of the highest order into the scenes of a drama, where the mood is clearly lyrical and where the emotional atmosphere of the action will be intensified in the audience by a corresponding orchestral expression. We can further imagine the co-operation of a great lyrical poet (whose poem might be effectively heard and not merely read) with a supreme master of orchestration who should adequately expound his work. Herein are great possibilities for the future. The work of composers like Mr Richard Strauss seems to point in this direction. The co-operation of Ibsen and Grieg in Peer Gynt and, quite recently, that of Dr Elgar and Mr A. C. Benson suggest wider possibilities.

V. PAINTING.

I HAVE in an earlier part of this lecture pointed
to prose-fiction and to music as the arts which most
adequately manifest the achievement of the nineteenth
century in art. But I maintain that though this be so
the other arts, painting and sculpture, architecture and
decoration, have not lagged behind, nay, that they
manifest in a most striking manner the same spirit
of expansion. And at the very outset I wish to warn
you of a pitfall into which we are all likely to stumble
when hastily judging of the achievement of pictorial
and plastic art, and which must make a just apprecia-
tion impossible. I am sure you have most of you
experienced with me the feeling of depression after
visiting an exhibition of modern painting or sculpture
followed by a visit to one of the great galleries of old
masters. We then sadly recognise the difference
between the two. But this is not fair, nor can it
lead to any just estimate of modern art. For re-
member that the modern exhibitions I am referring
to generally consist of the rather indiscriminate pro-
ductions of but one year, with works of scores and
even hundreds of contemporary artists (not often

artists who will live, nor even their own best works). These are brought together with comparatively no selection as regards standards of lasting merit; while the great national museums consist of the carefully selected masterpieces of immortal masters, whose merit and fame have survived the test of centuries—time itself having in the first instance exercised a most searching criticism and selection. Let me but suggest to you what an exhibit of but ten pictures, usually extending over say forty years only, would mean when the best modern artists are chosen. I can never forget how instructive in this respect was the Manchester exhibition of English masters of the nineteenth century, and what an impression the pictures as a whole produced upon me.

If we turn to painting we recognise the same widening range of vision for the artists with regard to nature and with regard to life. As regards nature, who will deny that a new and great conception of the province of pictorial art has come into the world with the advent of the nineteenth century? Has not Ruskin stated, at times overstated, the case? No doubt there are splendid landscapes by earlier masters, by Rembrandt and Rubens, Ruysdael, Hobbema; nay, are not the backgrounds of a Titian, even of earlier Italian masters, full of a truly artistic charm of their own? Did not the great Claude live and work in the seventeenth century? Did he not find a reflection in our Wilson? This is undoubtedly true. And yet landscape-painting as a great art may be said to have

been born to full life only in the nineteenth century. And this birth took place mainly in England.

As in the case of the novel, so here, the continuous development begins in the eighteenth century. Gainsborough is the starting-point in this case; yet in him, however stupendous the advance marked by his landscapes, landscape-painting was not the central sphere of his effort. More truly modern landscape may be said to have begun with Constable, who in 1820 exhibited his first landscape in the Academy. From his time on the development of landscape-painting is continuous, through Turner, Crome, and the Norwich school (with Cotman, the younger Crome, Stark, and Vincent) on to the great English water-colour painters, David Cox and Müller, De Wint, Bonington, Copley, Fielding, Varley and many others. The great impulse moves onwards and is carried forward by the French artists of the Barbizon School, to whom, as they fully acknowledged, the study of Constable and the appearance of English water-colours in the Salon of 1822 gave encouragement and enthusiasm as well as direction. Then begins in France a glorious development of landscape-painting of which Rousseau, Corot, Dupré, Diaz, Daubigny, and Troyon are the chief luminaries. From that moment every country in Europe has constantly produced masterpieces of landscape-painting which manifest a new feeling for nature as a subject for artistic presentation, of which the world before was not fully conscious.

In Germany we have Lessing and the Achen-

bachs and many others; and in England the host of artists who have produced and are producing great works in this direction are so numerous and so familiar that it would be vain to attempt to enumerate them and invidious to select from among them.

Not only in Europe, but in America as well, artists like Bierstadt and men of consummate genius like Innes and Whistler have widened out the portals of landscape art as but few have done before.

It is the stupendous variety of new subjects, new points of viewing and of reproducing nature, and new methods of artistic manipulation which makes this activity so confusing and elusive of classification. The general effect, however, which we realise most emphatically is this powerful spirit of artistic expansion.

The chief distinctive features of the modern landscape painter as compared with his predecessors is, in the first place, the general attitude he holds with regard to nature. He regards nature as worthy of observation and of artistic reproduction without any immediate reference to man, without borrowing any of its claim to aesthetic interest from the human or the anthropomorphic associations which it may have. Nature is no longer the background or the foreground, it is not even a setting for some scene of present or past life, real or imaginary, pictorially rendered ; but foreground and background and middle distance, earth and trees and flowers and mountains

and sky and clouds, are the organic parts of a composition with an artistic unity, which is to be found in the harmony of line and form and colour and light and shade, the spiritual associations which they evoke and the aesthetic mood in which they place the spectator. Yet with this creation of artistic unity, the component parts, and the individual features of nature which contribute thereto, are not subordinated to it at the cost of their own individuality. They maintain their claim to observation and to representation in art with truth to their own natural essence. And thus, as Ruskin has so eloquently shown, the modern painter deals with the land and the sea and the clouds, with trees and their foliage, with flowers, with the animal kingdom, in quite a different spirit from that which actuated the painter of old, to whom they were generally of subordinate interest; further than this, entering deeper into the more specifically pictorial attitude of mind, the interrelation of these parts of a landscape composition, the way in which each affects and modifies the other when seen with the eyes of a painter, the effect of light and shade, of a luminous foreground or background, the interaction of colour upon colour, the production of tone through the conjunction of these influences,—all these are observed, studied and rendered with a conscious attempt at mastering the difficulties of technical presentation.

The variety and complexity in the development

of modern landscape painting is still further in-
creased in that the several landscape painters and
their schools fix for themselves the subjective point
of view from which the artist is supposed to approach
nature as an observer or an interpreter. And there
are thus numerous gradations between the two ex-
treme views: whether, on the one hand, the artist
proposes to render all the details which he sees as
if he approached near to them in all the truth and
with all the intricacies of their beautiful organization
and form ; or whether, on the other hand, he supposes
himself to stand at a considerable distance, so that,
as it were, the independent voice of the natural
objects asserting their individuality cannot be heard,
and they all, becoming more passive, reassert their
life through the medium of observation and inter-
pretation of the artist; and they are therefore
obliged to resign themselves to the observation and
interpretation of the artist and trust to him to do
them justice. This he achieves through the *im-
pressions* which they evoke in him ; and he composes
or totalises the impressions, not the parts of the
landscapes themselves, into a harmonious composi-
tion. The man who adopts this theory is called an
impressionist. Between the extreme impressionist
and the minute objectivist (if I may use such a
term for want of a better) there are numerous grada-
tions and complications. Moreover the impressionist
may himself, through his own personal artistic equa-
tion, be more open to one class of impressions than

another : to colour as such, to chiaro-oscuro, to the
unity of line or of masses, or to the almost musical
vagueness of mood which either of these, or all
together, evoke. It is in deference to this fancied
analogy to music that Whistler calls some of his
interesting impressionist sketches symphonies in blue
or green or yellow.

Added to all this we must remember the fact
that the older and more anthropomorphic point of
view of regarding nature, with the more conven-
tionalised methods of presenting her, remained a
possession of the painter of the nineteenth century ;
and that, converting this into a consciously historical
attitude of mind, he increased the variety of points
of departure for landscape painting and produced
a large number of interesting works. The central
activity of the landscape artist of the nineteenth
century however remains, the directness with which
he approaches and enters into nature. To give but
one more illustration of this, let me merely refer to
the so-called *plein-air* school. So strong was the desire
to approach close to nature and to push aside the inter-
ference of every convention established by the past,
that the landscape painter spurned the effect of studio-
light in his picture. This he thought false, not true to
fact, interposing a human and artificial condition upon
nature as she appears when we leave the walls of
human habitations—even the studio of the artist.
And thus he aimed at reproducing the effects of
form, of light, and of colour as they appear in the

open air in the heart of nature herself. What he forgot is: that the picture itself is seen in a room or, at least, a gallery; that a work of art is directed towards *aesthetic* contemplation; and that a certain amount of human, "domestic" convention or idealisation or interpretation—or whatever else we choose to call it—is required to guide or force men into the aesthetic mood.

Leaving the sphere of pure landscape we have in painting, as in literature, the new attitude of the artist with regard to life:—new nature and new life combined into a new category of pictorial art. Man is no longer to be seen only in striking or formally attractive or spiritually elevated scenes and actions and attitudes, nor only in the town or in the streets or in the inns of the Dutch painters; but in nature herself, affected by her, affecting her, working in her. While thus in France the more "Classical" aspects of pictorial art, which were and are so well worthy of the attention and efforts of men of talent and genius, flourished under such masters as Ingres, Ary Scheffer, Jerome, or in our own days Bouguereau, Baudry, Lefevre, Henner, Meissonier, Bonnat, Carolus Durant, and many others, a new spirit, endowed with vitality by the Barbizon School, entered into the souls of those artists who meant to present human life as such. Thus in a J. F. Millet, the observation of the actual life about him in nature led to a presentation of that life in the same penetrating and catholic spirit which actuated the landscape artists of that

same period. Millet saw and felt natural poetry in the actual daily life about him, and he insisted upon the poetry of ordinary life in his art. Above all he became the artist of peasant life in the fields, combining in his pictures all the charm, all the living intensity of observation of the landscape as he saw it, with the beauty and the poetry of man as he lives and toils and rests among the fields and their vegetation.

Without the sense for the poetry, yet with almost a greater intensity of delight in the feeling of man's life face to face with nature, Courbet penetrates still further into the existence of modern man. And then comes Manet, who, with some violence and insistence, still further tears down the barriers that separate actual life from the domain of art, and in doing so protests against the limitations of method in pictorial technique, introducing new modes of presentation with the brush which were hardly intelligible to those who first beheld his works. This delight in technical vigour, coupled with a narrower range of vision and imagination led Degas, the *virtuoso* in draftmanship, to exert his energies in studies chiefly in the Parisian cafés and behind the scenes of the theatres. His rendering of the theatre is most untheatrical: it is the life within the counterfeit.

Yet with all this delight in the actuality of life, the poetry of it, which stirred the soul of a Millet, is revived in the delicate and vigorous art of a Bastien Lepage. And I do not mean by poetry the

custom of appending a long poem to the frame of
a picture ; but I mean that unity of artistic spirit
which comes to a work when every part of it, of
the subjects presented as well as of the means of
presentation, concur, flowing into one another towards
that spiritual unity which gives true artistic life to
a work of art. Take, as a characteristic illustration,
the manner in which Bastien Lepage deals with even
an historical subject of the remote and romantic
past, of the middle ages, the story of Joan of Arc.
He does not present this heroine in armour on a
prancing steed amid a host of mediaeval mercenaries
or in the heat of battle, but he paints a French
peasant girl in a French peasant garden with the
poor cottage in the background. The landscape in
which she is placed conveys to the eyes of the
spectator convincingly the physical facts and the
spiritual atmosphere of the country home and the
life of the peasant girl as only a modern landscape
can. And then he places within this landscape in
the foreground the remarkable type of a girl, the
woman of the soil, as she is now and as she was
in the middle ages. In the face, in the eyes, and
in every feature he imparts the story of a great
and potent imagination, wide and lofty as the skies,
yet cramped within the walls of the cottage and the
laborious fields of the farm. The expression is that of
supreme exaltation, of a trance-like vision, the vision
itself made clear to the spectator by the shadowy
picture, floating in the air, of the girl herself arrayed

in full armour. The whole story is told, and told moreover *pictorially*, not only by the actual objects and details of the girl and her vision; but by the mysterious grey tone, luminous withal, by the colours themselves, and the way they are applied, and the lines and the forms—in short, all the technique of the painter's craft. Yet all these means converge into artistic unity, preparing and intensifying directly, through the senses themselves, the emotional mood corresponding to the clear facts which the painter's story conveys to the intellect. This class of work I maintain is an achievement of the nineteenth century.

Leave France and let us for a moment go over to Germany. Here we have in the earlier days the genuine Classicism of a Carstens and the so-called Nazarenes who derived their inspiration from the early Italians; we have the Munich School of composition and line without great development of colour or brush-work in Overbeck, Cornelius, Kaulbach, Preller, and later Piloty and the Austrian Makart (who did know what brush-work and colour meant). We have true poets in painting like the great Feuerbach and weird mystery in Gabriel Max; and then we have the truly great modern artist of life, king of draftsmen for all times, Adolph Menzel, still among us as an advanced octogenarian. In him the gospel of direct and truthful rendering has ever been supremely active, whether he dealt with the past or with present life. Then we have the great master

of portraiture, Lehnbach, a host in himself; until we come to that confusing variety of vigorous life in the original work, both as regards subject as well as technique, of Leybel, at once a minute objectivist and an impressionist, in the weird poetry of colour and form of Boecklin, in the varied and often conflicting schools of pictorial conception and technique of Thoma, Klinger, Stuck, von Uhde and Liebermann. And besides the variety of technique and subjects there is a world of new *thought* infused into the pictures of these artists.

In no country, however, has this expansive life in painting been more vigorous and varied than in England in the further development of the nineteenth century. The spirit which moved a Millet and a Bastien Lepage finds its parallel in Mason and Walker and Lawson. Take Watts, in whom, as it were, the love of the Elgin Marbles is blended with that of Titian or Giorgone and grapples with the great ideas and problems of modern life, and contrast him with the later Millais. Cast your eyes over the works of Richmond and Leighton and Tadema and Poynter and Herkomer and proceed to the pictures of the Americans Whistler and Sargent,—in whose method of pictorial expression almost a new language has been discovered,—and you will realize the vigour of the stream which can bring to the surface such a variety and diversity of artistic achievement.

I have before this mentioned the new historical point of view in art adopted by the nineteenth

century. As in poetry and fiction, so in painting
this has found expression in pictorial language by
means of which the painter conveys his meaning.
This has led to the production of a class of paintings
which adds a marked feature to the characteristic
and individual physiognomy of nineteenth century art.
I am not only alluding to the distinctly "historical"
painting as we find it in the pictures of J. P. Laurens,
where all historical details, true to the period chosen,
harmonise with the peculiar colour and tone, which
again emphasise the essential character of the scene
depicted; not to such an excellent work as Mun-
kacsy's "The Blind Milton and his Daughter,"
where the atmosphere of the past age, the complex
suggestions of the great blind poet's life and work,
are conveyed by the actual technical means of
drawing and colour; not to the work of Orchardson
or Abbey, possessing similar qualities; I am referring
chiefly to that interesting artistic movement embodied
in the works of the English Pre-Raphaelites.

Curiously enough the Pre-Raphaelites began their
activity starting from the same impulse which moved
the French naturalists such as Courbet and Millet.
It was a protest against formalism in art and a
passionate desire to return to nature. In opposition
to the formal beauty of the *Cinquecentists* they found
more of this actual truth to nature in the *Quattro-
centists*, in the sincere and loving delineation of
details and a childlike simplicity in form. Very
soon, however, they ignored this primary cause which

led them to the study of the ancient artists, as well
as the truthful, simple rendering of detail ; and they
became enamoured of the quaint spirit from which
these characteristics had emanated. They were
thrilled with the suggestion of poetry in that more
childlike attitude, identified with greater spirituality,
as opposed to the sane delight in the beauty of
physical form which through the Greeks had flowed
into the blood of the Italian artists of the later
Renaissance. Spiritual beauty is thus opposed to
bodily beauty. The expression of such spiritual
beauty, owing to the historical origin of their own
later development, led them specially to precursors
of Raphael, and to the life and spirit of the age to
which they belonged. No doubt there is a touch
of "Romanticism" in this; and the mystical side
of "Romanticism" had before their advent found
supreme expression in the genius of Blake. But the
English Pre-Raphaelites were consciously modern
men, who, recognising spiritual and artistic qualities
in one bygone age, filled themselves with the poetry
of this and wished to engraft it upon the stem of
a modern and living art. The curious fact is that,
starting from a naturalistic basis, they soon found
themselves in direct opposition to the naturalists
and realists of modern times. But they were not
Romanticists, in so far as they wished merely to
develop the poetic and spiritual side of modern life.

The works emanating from this truly remarkable
movement present the greatest variety. Maddox

Brown blends after a curious fashion the actualities of modern life with the childlike spirit of a Pre-Raphaelite painter; while Holman Hunt, Rossetti, and Burne-Jones, under the influence of an intense feeling for beauty of decorative design and brilliancy and harmony of colour carry the consciously historical attitude of mind to a higher degree of artistic perfection. The poetry of their art has found a response in the taste of people far beyond England, and meets with a sympathetic and independent development in pictorial methods differing from them, in the work of Puvis de Chavanne. The career of Millais is most interesting and significant. He starts with the Pre-Raphaelites in being inspired by the Quattrocentists, because of the love of nature; but leaves them at their second stage and becomes, in feeling as well as in technique, a pronounced champion of modern naturalism.

Time will not admit of my entering into even a sketchy account of the rich development of pictorial art in other countries of Europe and in America. Spain alone, with the striking development of new feeling and new methods, where the vigorous work of Goja is carried on by Fortuny, Pradilla, Villegas, and so many others, would illustrate the expansive vitality upon which I have been insisting. The same can be noticed in Italy, Belgium, Holland, Scandinavia, Russia and Hungary. But I hope that even this hasty survey will have helped you to realise the artistic vitality of the age we have just left behind us.

VI. SCULPTURE.

I FEEL sure you will think that, at least in sculpture, the nineteenth century has lagged sadly behind and has given no evidence of carrying the torch of that art further onward. Well, even here, if you will take the trouble to study the works of sculptors which, it is true, are scattered all over the world, with the view of recognising the main currents of their activity, you will see that here also there is evidence of the spirit of expansion. In the works of Houdon we already note the end of the Rococo period and the beginning of the new impulse which finds its pronounced expression in our later days. It is true that there is an intervening period (corresponding to the Empire style of architecture and decoration) given up to a colder and sometimes lifeless classicism. I mean the period of Rude, Thorwaldsen, Canova, and Flaxman, though this last is to my mind one of the artists most directly imbued with some pure qualities of Greek art among all his contemporaries. But soon the current sweeps on through Pradier, David d'Angers, Guillaume, and Chapu to the naturalism of Carpaux; while Barye

shows his direct love of nature in his powerful rendering of animal life. This feeling for life is carried into peculiarly Parisian channels in Jouffroy and in Falguière, whom I may call the Degas of sculpture during the second empire, until the spirit of revolt against the narrower limitation of established art finds its supreme expression in Rodin.

In other countries as well we can recognise the same development in sculpture, running parallel with that which we have noticed in painting, in music, and in literature. From Chantrey, Nollekens, and Foley in England, we pass on to Boehm, Thorneycroft, Onslow Ford, Gilbert (in whom the historical side has been most subtly blended with the vigour of modernity), Brock, Frampton, and many others.

In America history and modernity are united in the soul of a truly original artist, St Gaudens; while artists like French and like McMonnies carry into contemporary life the spirit of bold, vigorous naturalism with the strong sense for striking decorative effects.

In Germany the older artists like Rauch are followed by Zumbrusch and Hildebrand (with his complex historical and still naturalistic feeling) and Begas and Klinger, where sculpture is at once naturalistic and mystical.

But the most pronounced and characteristic movement in sculpture, expressive of this expansive development of the nineteenth century, is to be found in the schools of France, Belgium, and Italy

which culminated in the pronounced type of Rodin's art. This school is in direct revolt from the older traditions of plastic art. It is a deliberate and conscious attempt to break loose from the trammels imposed upon that art by many centuries of efforts, of experience and of achievement. It is anti-formalistic, because it feels that formalism blocks the way to the adequate expression of nature, of life, and of thought. The stronger feeling for texture, the outcome of this desire for nature, strengthened in the sculptor by the achievements in this direction of pictorial art, lead to a different system of modelling, a different manipulation of stone and of bronze, in which the uniform smoothness and finish of surface is broken into by rough masses presenting an infinite variety of minuter surfaces, each absorbing or reflecting light to a different degree. We see the sculptor struggling to approach in adequacy and directness the painter's power of rendering the different forms, bodies, and textures in nature. It is significant to notice how attempts to apply colour and to combine different materials in works of sculpture increase in number. It is true that these attempts are mainly confined at present to small decorative works, statuettes or plaques or the work of the jeweller. But they will not remain there. And I venture to predict that the principle of polychromy, which led the Greeks to add colour to form, will more and more be acknowledged in sculpture. Perhaps I may be allowed to confess that for many years I could not put myself in

sympathy with many genuine sculptore of the type of Rodin, and the rough and broad impressionist manner in which they worked their uncoloured statues in stone and bronze. For I felt that the sketchy and unfinished character, the suggestion of the accidental which the appearance of such works produced, were contrary to the essential nature of sculpture. Owing to the material with which it deals, sculpture is above all monumental and lasting, and not ephemeral and accidental. But I learnt to recognise the justification of artists of the Rodin type when I realised that the range of sculpture, as regards subjects to be presented, has expanded in our own age ; and that the new forms of expression which these new ideas required have shifted the monumental qualities of sculpture on to a different plane. The ideas themselves may give a large and monumental character to the work, if they are adequately expressed. Let me illustrate this by but one instance chosen at random, of a portrait statue of a man, presented down to the waist in a reclining attitude leaning his head on his hand, which I saw at the Paris Exhibition last year. It is by a sculptress, otherwise unknown to me, an Austrian lady, Teresa Theodorovna Ries. This portrait statue is in the main roughly blocked out, with apparently unfinished surfaces, which may, to the superficial observer, convey the impression of sketchiness. Yet even the superficial observer will have to realise that the type of man here represented is that of a deeply thoughtful

worker, advanced in years, who is essentially strong, mild, and, above all things, serious. The really important features of the face are, without caricature or exaggeration, given in a marked and plastic manner ; the unimportant details are not obtruded and do not attract the eye by their meretricious smoothness and elaboration. In the face and in the attitude, the main leading ideas conveyed by the appearance of this man, whose character stands out so clearly, are "eternalised" in the marble, and this, not by vague suggestion, but by broad insistence. And this "sketchy" treatment of the greater part of the work, so far from conveying a light and ephemeral impression and thereby counteracting the monumental quality, helps by its subdued elimination of finish to accentuate what is really lasting and monumental in the subject itself. The same applies even in a stronger manner to many, though not all, of Rodin's works. No doubt future sculptors will stand on his shoulders and reach to greater heights. But the main fact which I wish to convey is that in the nineteenth century sculpture has widened its range of subjects for presentation: not only nature, but the whole of thought, past and present, is claimed to be within the range of the artist. To make good his claim the sculptor has devised new methods of technical manipulation.

Had I but time I could lead you further into the numerous by-ways of plastic art on its more decorative side, which shows endless variety of effort and achievement in our times. For not only are new methods

of manipulation, and new combinations of materials attempted and carried out, but all the old methods are revived in a new and striking manner. Consider the vigorous life of the *medailleurs*, the modellers in small bronze relief, especially in France, of the goldsmiths and enamellers, who have enforced the new character of modern naturalism into the old technique or, with conscious appreciativeness, have endeavoured to convey the spirit of bygone days! I cannot refrain from singling out one work, small in size, by Lucien Falize, a gold triptych which reproduces in translucent enamel a piece of tapestry preserved at Sens. It adds to the mediaeval design and brilliancy of colour a touch of the living modern lover of the past. And now we turn in the last place to decorative art and to architecture.

VII. ARCHITECTURE.

In the case of architecture, more often even than in that of sculpture, I have heard it said, that the nineteenth century was entirely at fault; that we had developed no style, and could only give poor imitations of what bygone ages had evolved. This last word "evolved" furnishes an answer to that statement. No style of architecture was ever produced as was Athene who sprung fully armed from the head of Zeus. It is always due to a process of evolution; and if this process was ever visible, it is visible in the nineteenth century. But the process is confusing to the theoretical and critical observer, because there are so many influences at work which flow together and contend with one another in the turbulence of artistic expansion.

The earlier years of the nineteenth century were still dominated by that splendid and refined development of architectural art, refined without being weak, passed on by the Adams's and their followers. But the expanding movement manifested itself soon, even in the Victorian age, though it may have led to the production of works inferior in quality. For it was

the introduction of cheap processes, of mechanical
facilities and manufacturing skill, which led to the
production of this inferior work and of sham. Out
of this supply grew to a great degree the vulgarity
of taste. But from this side the process has been
steadily growing of adapting the new methods of
mechanical production to true art ; and thus the
higher forms of art may be accessible to thousands
instead of individuals. We are in fact still working
out the problem of how to harmonize the mechanical
and the artistic.

The moving spirit manifests itself still further, in
our constant shifting from one past style to another.
Gothic revivals have been followed by the revivals of
classical styles, and we have, besides, the later adap-
tations of those styles in France and England, while
in America a revival of pure Greek style is in force.
Yet this does not mean that we are eclectic, that we
painfully piece together various historical styles ; nor
does it mean that we slavishly follow the past. It
means rather that we appreciate to the full these
various forms, and that we take pleasure in them in
virtue of that new historical sense which marks the
genius of the nineteenth century. And, as in the case
of the Pre-Raphaelite painters, the inspiration coming
from the bygone age does not eliminate the direct
expression of sincere originality in the true artist of
the nineteenth century. Though a Richardson in
America may be attracted by the main features of the
Norman style, the same attraction produces a new

and distinct creation in architectural art. For apart
from the national character of such personalities, two
main factors are strongly at work in these architects
of the nineteenth century, and influence them just as
similar factors influenced the architects of an earlier
day when former styles were established. I mean
the idea of construction and the application of new
materials. By construction I mean in this sense
the adaptation of the work to the purposes which
it is to serve. Think of what the new social and
economic conditions of modern life mean as regards
the requirements of new buildings. We can realise
this fact best in countries least hampered by old
traditions where the developments of modern life
are most manifest and active, such as the United
States. Here the town-house and country-house in
the greatest variety are demanded by the new con-
ditions in which the national and economic growth
has placed the people. Nor is the architect restricted
or hampered by the re-echo of civic or feudal tra-
ditions obtaining in the old world. Remember also
the problems and possibilities presented to the
architect by larger buildings, hotels, flat-houses and
huge business establishments. In considering these
we are too apt to ignore the lesson conveyed by
Spinoza in the passage which I have chosen as a
motto to this lecture. I am of those who would
believe that even the so-called sky-scrapers can be
converted into imposing tower-like structures which,
if properly distributed in a town, may make these

most impressive and picturesque cities of modern life
and work, if only competent public boards of super-
vision had power and were made to use it. The same
applies to railway-stations and exhibition buildings
and many other structures specifically the outcome of
modern times. Of one thing there can be no doubt :
that the opportunities for a high development of
architectural genius are before us ; and I confess to
belong to those who are sanguine, while recognising
the futility of some isolated attempts.

VIII. DECORATIVE ART.

FROM architecture we are naturally led to decorative art. To the superficial observer it may appear that the human brain and hand have during countless ages discovered nearly all the possible decorative forms, and that it only remains for the future to repeat what has been established or to make new combinations of old forms. Yet decoration is in one sense one of the purest of arts, one of the arts least dependent upon actual imitation of objects existing in the outer world, and in so far it is a most sensitive vehicle for expressing artistically the characteristics of different ages and nations. The nineteenth century, with its eyes open not only to the past of each country but also to the life of remote regions, has had presented to it an interesting variety of decorative forms which it could adopt, assimilate and modify. Yet, allowing for this fact, it has seen the rise of new schools and styles of its own.

Let me but draw your attention to two such instances. The first is the new departure in decorative art marked by the work of William Morris

and his followers. The other movement, active in our own days, has been called *L'art nouveau.*

The work of William Morris is characterised by the deepest insight into the past. But as a true and deeply sincere artist of the nineteenth century, alive to all the actual needs of the present, and still more straining towards a desirable future, his historical sense is permeated by the love of truth which forced the literary as well as the pictorial artist to face nature. In decorative art, however, this truth does not mean, as it does for instance in painting, actual accordance with life and nature ; it turns upon the beautiful and genuine treatment of the material, avoiding every shadow of sham, upon the honesty of the design, whether it be conventional or naturalistic. To my mind it is the fusion of these two qualities, the historical sense and the sense for truth, both so characteristic of the best art of the nineteenth century, in William Morris, which make up the essence of his art ; and this genuineness, in its turn repudiating conventionalities in life as well, made an appeal to the simpler aspect of social existence, and thus found its way into humbler homes and simpler lives, whither genuine art of a higher character had hitherto not penetrated. It was by this spirit that the home life of England was revolutionised in the second half of the nineteenth century, as regards its artistic manifestations, the adornments of the articles of use, the surroundings of domestic existence in house and home. And

though, like all powerful movements, it may often have carried people too far into turbid insincerity and affectation, there can be no doubt as to the widespread and penetrating influence of this national movement in England.

From furniture through utensils and adornments of daily life, from textiles to wall-paper, the decorative art with which the name of William Morris will ever be associated has created a style which will always characterise this period in the nineteenth century.

The influence of this English movement has made itself felt far beyond the bounds of this country. It has penetrated into most civilized centres of Europe as well as of America, and I have reason to believe that it has had something to do with the production of *L'art nouveau* which, in some respects, differs so markedly from it. *L'art nouveau* has been jocosely described by a writer in *Le Figaro* as *L'art de nouilles et d'os de mouton*, the art of macaroni and the mutton bone. There is enough truth in the description to recall its characteristics to your mind's eye. But the spirit out of which it has grown and its actual historical origin are directly illustrative of some of the main features of nineteenth century art. Negatively it arises out of the weariness of the constant reproduction of the old established forms hitherto prevalent, or, at least, this weariness prepared people to crave something new. The originality inherent in Morris's style formed a foundation upon

which was built up a decorative structure, the building material for which (if I may carry on the metaphor) was brought together from all distant parts of the globe, and the cement for which were the new materials and the new mechanical processes of production with which modern industrial life has furnished us so plentifully. I think I can trace the actual origin of this *art nouveau* in its earliest forms. It was born I believe about the year 1875 in the United States of America, where the Philadelphian Exhibition had brought together specimens of decorative art, especially as applied to domestic architecture and furniture, from all parts of the world, including the work of the Morris school. But, besides those, the decorative achievements of the far East, especially of Japan, already familiar to many individuals, were then brought near to the industrial artists and decorators of the United States. With the unprejudiced freshness and progressive energy which delights in the creation of new things, the furniture-makers and decorators of that country combined elements taken from Japanese art with those of European art as represented by Morris. And thus, in the wood and stone-carving which adorn the buildings erected that year, as it were in protest against the lifeless decoration of the "brownstone-front" houses erected by the hundreds in the streets of New York, we recognise the fusion of these influences and especially the touch of Japanese style. The original designers, some of them men

gifted with the highest artistic sense, who worked
especially for wood engraving, went further yet.
Perhaps it was in Vedder's illustrations to Omar
Khayyam that the style found its first expression.
Look at the paper covers of the *Century Magazine*,
started about that period, and note the quality of
the design (due I believe to Vedder), and you will
recognise the essential elements which characterise
L'art nouveau.

It was from America, perhaps through these very
illustrated magazines, that the style was introduced
into Germany (where I believe they now speak of
a "*Jugendstyl*," from the illustrated paper of that
name), as well as Austria, France and the Continent
generally. In saying this I do not wish to detract
from the originality of those who have developed
this style in the various national centres—nor do
I even mean to imply that the originality is of a kind
that is always worth preserving. Nothing could in
any way be more original than the remarkable draw-
ings of an artist like Aubrey Beardsley. Yet even
he must have been affected by the current that
streamed over the western world and brought with
it the art of the far east which it mingled with the
spirit of Morris and the Pre-Raphaelites.

I have carried you far afield in this lecture: we
have visited many countries, men and their works,
and have touched upon many topics of deep interest

and concern to us all. Little as I have been able to say in this scanty allowance of time it will, I hope, at least have impressed upon you the fact that the nineteenth century was a great age of expansion in art, and that this expansive vitality is as expressive of an onward movement as is the progress in science, which is doubtless a leading characteristic of the nineteenth century. The observations which I have just made with regard to the development of decorative art point to another characteristic of the nineteenth century which manifests itself even in art and will always remain one of the most marked features of that age, in spite of the recrudescence of narrow and envious nationalism. It is the spirit of a widening sense of human brotherhood over the whole globe. While we cordially welcome the appearance of every symptom which points to the spread of this spirit, we need not fear that it will lead to the destruction of the individuality which is so dear to the artist. There is no need of artificially preserving the instincts which make for individualism. The individualism that is worth preserving is not endangered by the centralization of modern life. Even the tendency to centralization in great cities like Paris and London has not destroyed the marked characteristics of the Norman or the Gascon, of the York-shireman or the Cornishman. The unification of Italy has not obliterated the distinctive characteristics of the Piedmontese and the Neapolitan. Look among your next-door neighbours, nay within your

own family springing from the same blood, and see whether the individual characteristics are not sufficiently marked. Freedom and individuality and originality, if they deserve to live, will look after themselves. There is diversity enough in the world ; but there is also, let us hope, unity, at least in our highest ideals. We are all in our various ways striving after what is best. You have come here united in one high aim. You represent all quarters of the globe and many of its nationalities, and in selecting this place for encouragement and guidance in your studies, you have done honour both to this old seat of learning and to the ideals which we all have in common.

Printed in the United States
By Bookmasters